"It takes a special presence to witness, then capture, the extraordinary moments of ordinary, everyday life. *Linger Longer* is a love poem to the universe: arresting and visually intoxicating. It dares us to believe that we can find possibility and personal empowerment in a teacup, a potted plant, an open field, or a closed door; these moments are revealed in the least likely of places . . . even the broken ones. Allow Carol's pictures and words to bloom in your heart. Feel these universal messages of spirit and gratitude, all revealed as an act of love expressly for you."

**—Monica Rodgers**
Founder, The Revelation Project

"*Linger Longer: Lessons from a Contemplative Life* is a glimpse into the awakened soul of Carol Mossa, a healer, teacher, writer, and photographer. What's more, her soul beckons yours to come out and play, to notice the world in new and astonishing ways. You'll never again look at peeling paint, a budding flower, or a rusty hinge in the same way. Carol shows us that there is beauty everywhere, in everything, and she always finds the exact sentiment that has you nodding, 'Yes. Of course. Exactly.' This book is destined to become a daily meditation and art gallery all rolled into one."

**—Linda Lombardo**
Producer and host
The Voice of Leadership Radio Network

"From Carol's contemplative world comes an extraordinary wellspring of wonder, woven with wisdom and healing words. This inspiring book represents Carol's commitment to her meditation journey and demonstrates that she is no stranger to 'lingering longer.'"

**—Ann M. Porto, PsyD**
Clinical psychologist
Sound energy healer and meditation instructor

# Linger Longer

Lessons from a
Contemplative Life

## Carol Mossa

BROWN BOOKS
PUBLISHING GROUP

# Introduction

On October 15, 2014, a few months shy of my sixtieth birthday, I embarked on a solo cross-country road trip. I packed little beyond a few changes of clothes, my camera, a few hundred *Earth's School Of Love* greeting cards to sell along the way, and a big dream. That dream was to see this great country of ours through a contemplative lens and to prove to myself (and my youngest daughter, Lindsey) that I was, indeed, a first-class traveler. Blessedly, I put 9,500 miles on my humble 2012 Hyundai Elantra, I slept in nineteen different *Airbnb* homes, I reconnected with cousins absent from my life since childhood, and I made a whole host of new friends. I knew early on, during the planning stages of the trip, that given the brevity of my crossing (thirty days), this was not going to be about *sightseeing*, at least not in the traditional sense. But make no mistake; the sights I did see were breathtaking, rich, multi-dimensional, and varied. The photographic work I did was deeply contemplative, personal, and public at the same time. I have included the Saturday, October 18 post from my blog, *hjfree.blogspot.com*, *Linger Longer*, because it speaks eloquently to the trip itself, the work I present here, and the manner in which I choose to occupy the world on a daily basis. Namaste.

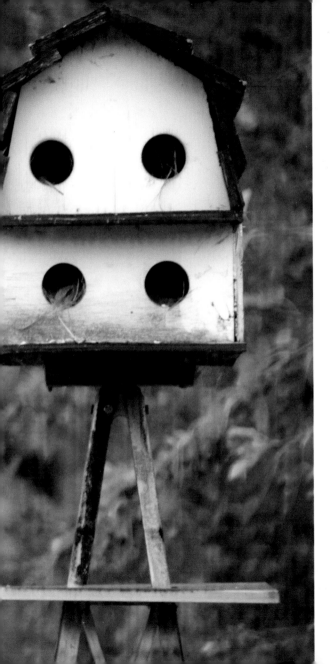

## Linger Longer

Early last night, after checking into my apartment in La Crosse, Wisconsin, for the night, I decided to head into town for some fellowship. Not knowing my way around, I gave myself plenty of extra time to find the meeting place. Driving down the street, not too far from my apartment on the Mississippi River, I passed this handcrafted, well-lived-in birdhouse. My muse told me to stop and take the picture that she had already conjured up in my mind's eye. Fear said, "Better not. You'll be trespassing." Fear won out, ever so briefly, and I kept driving, but not for long. Seconds later, I made a hasty K-turn in the middle of the road, and returned eagerly, to capture the moment.

I parked the car, grabbed my camera, jumped out, and took the shot. At that moment, I knew, intuitively, that I had to be on higher ground for the shot to work, for the Mississippi River to be glorified in the background. So, I did what any self-respecting photographer would do—I climbed onto the trunk of my car! From that perch I snapped away and ultimately walked away with this image and several others.

The lesson is always mine, and for me, on this trip, the message that I've learned, and hope to convey in my work, is *linger longer*. Wherever you are. Whatever you are doing. Be in the moment. Be present. As poet Mary Oliver writes, and I so often quote, "Pay attention. Be astonished. Tell about it." Even though I am breezing through towns across this great country, paying homage with one-night stands, make no mistake; I am missing nothing. This was never intended to be a sightseeing tour. The sights I am seeing may not be the popular ones, the ones people seek out on vacations, the ones advertised in travel brochures, but the insights from lingering longer over the ordinary, the mundane, the discarded, the overlooked are powerful.

I wish you time to linger longer today and every day.

Love, Carol
October 18, 2014

1

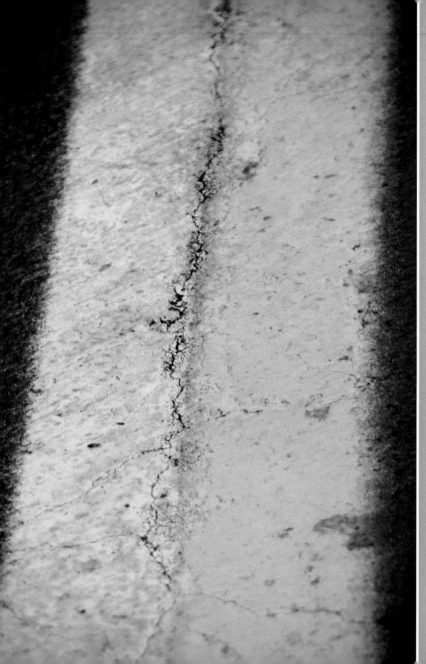

*Buffalo, NY*

That miracle you're waiting
for is just ahead. Don't quit.

*Buffalo, NY*

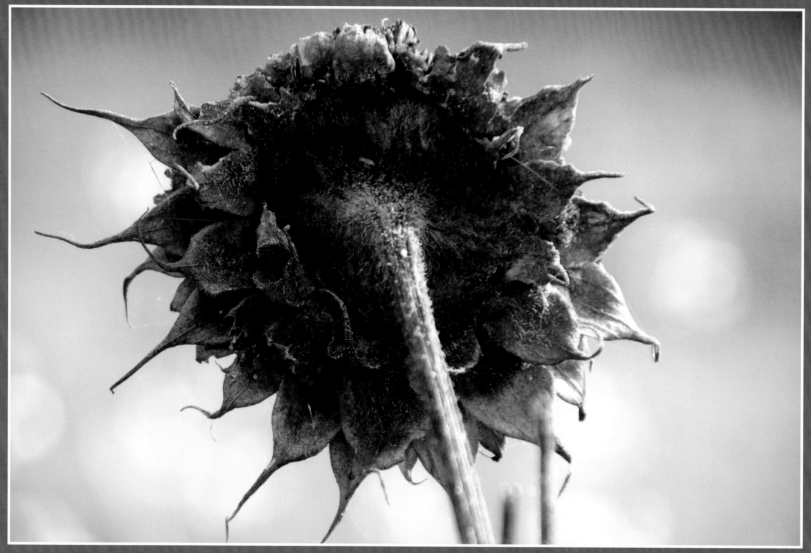

4

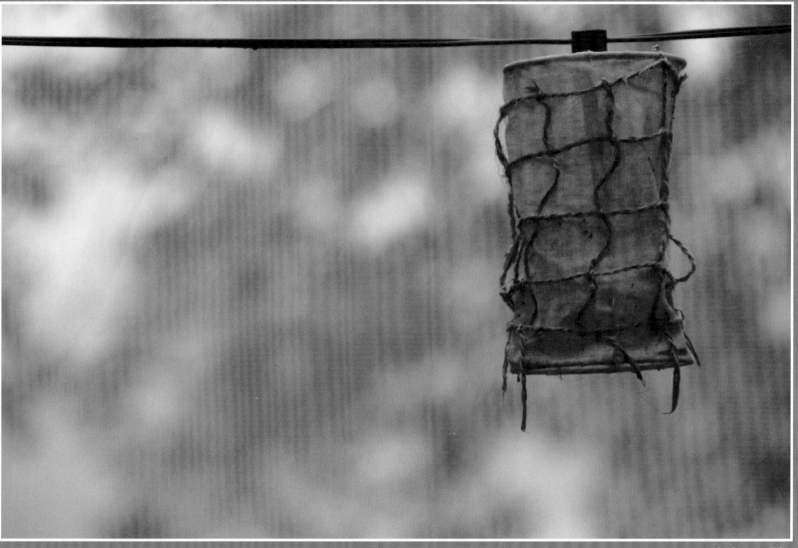

*LaCrosse, WI*

**In a world of look-alikes, there's no one quite like you.
Don't hide in the crowd.**

*Sioux Falls, SD*

**Stop playing small. The world needs you.**

*Sioux Falls, SD*

**You'll feel the writing on the wall long before you ever read it there.**

*Sioux Falls, SD*

*Sioux Falls, SD*

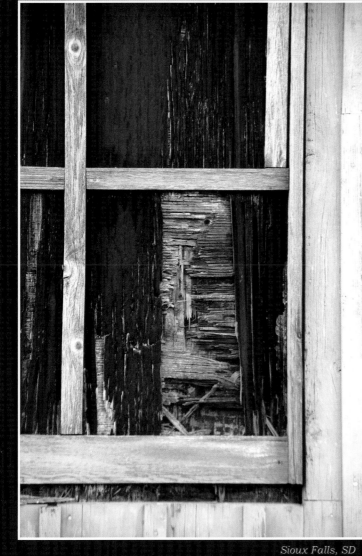

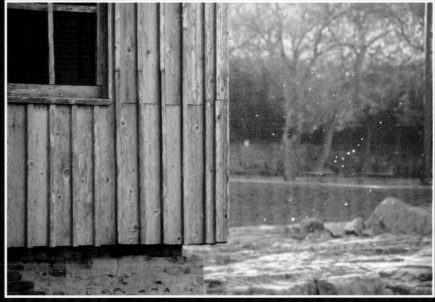

**It's the chips and cracks that
reveal character and beauty.**

Rapid City, SD

Sioux Falls, SD

10

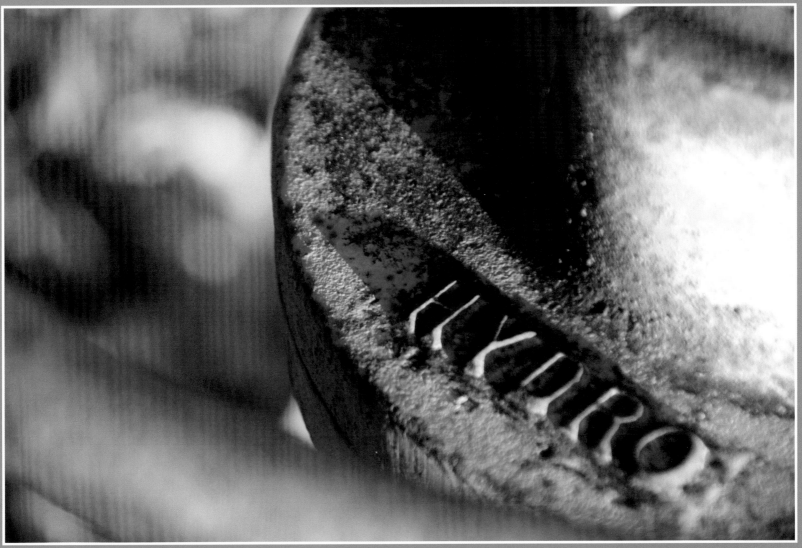

*Rapid City, SD*

*Rapid City, SD*

I love waking up to you.

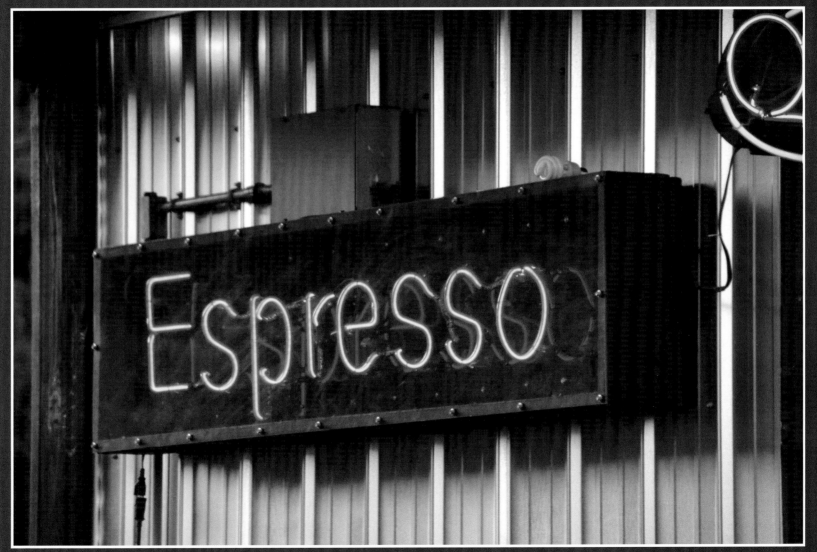

*Missoula, MT*

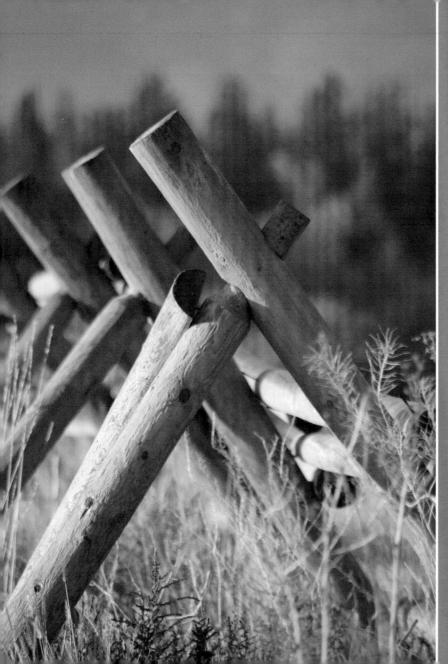

*Missoula, MT*

Sometimes, those fences we
erect to protect keep out the
very thing we need to grow.

*Missoula, MT*
*(opposite)*

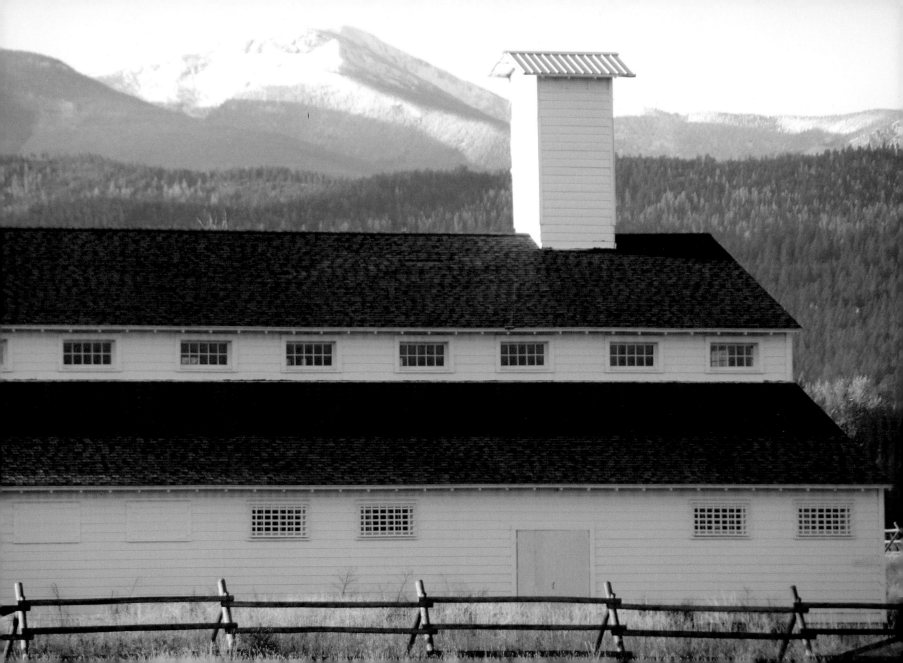

**Practice fear less.**

*Missoula, MT*

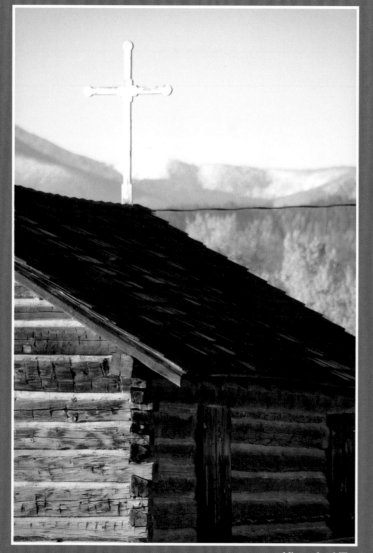

**Not all geography lessons are in books.**

*Missoula, MT*

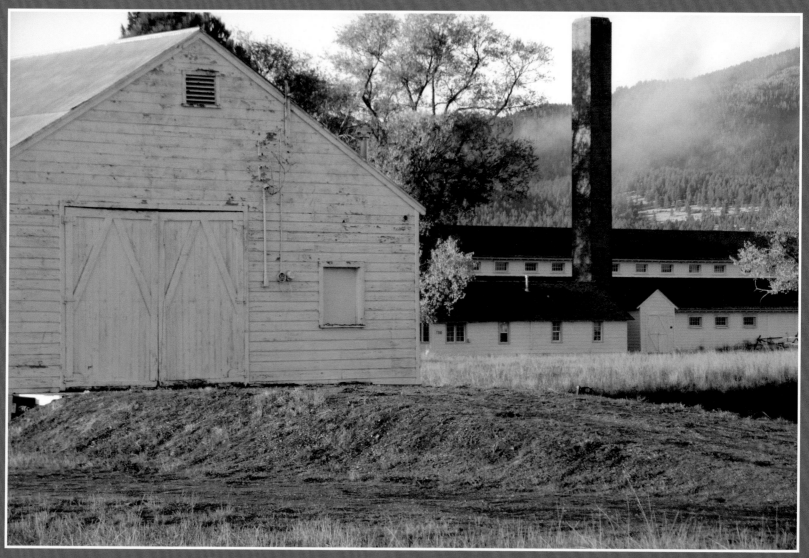

*Missoula, MT*

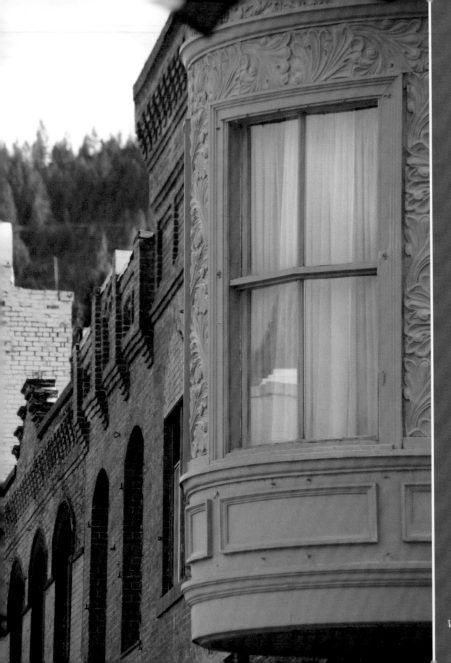

If you're on the outside looking in,
adjust your gaze.

*Wallace, ID*

Love has no expiration date.

*Wallace, ID*

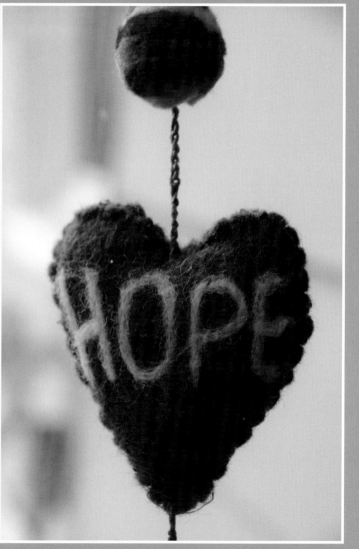

Not everyone plays with a full heart.
Choose your teammates wisely.

19

*Spokane, WA*

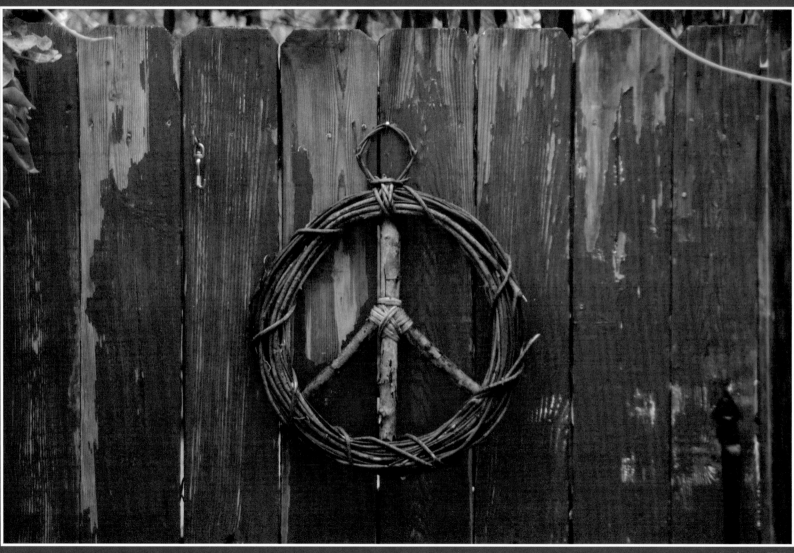

Spokane, WA

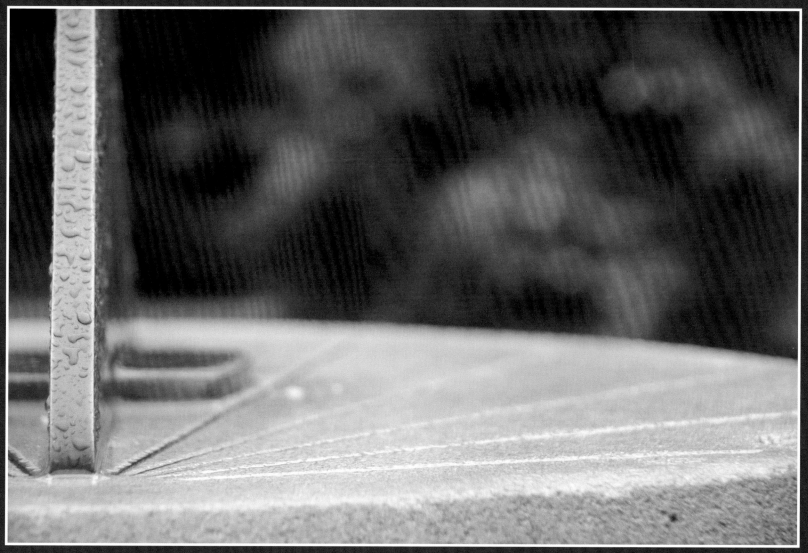

*Spokane, WA*

Practice presence.

*Seattle, WA*

22

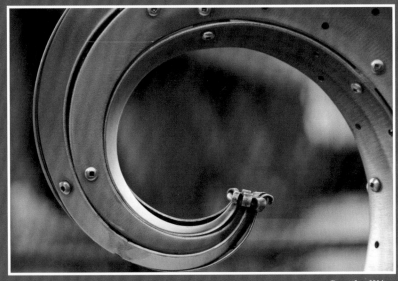

There is nothing abstract about the workings of the Universe. Want a lovely life? Love your life.

*Seattle, WA*

Release them with love. No matter what happened. No matter how long you journeyed. The lesson is always yours. Thank them.

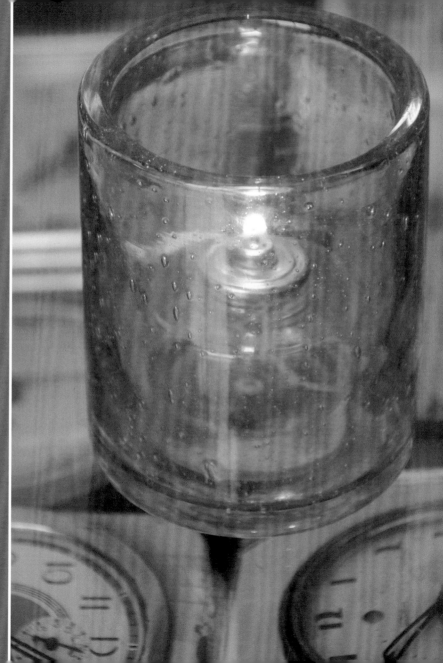

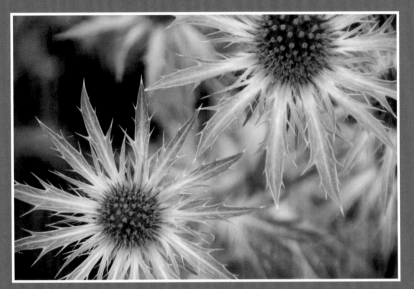

*Seattle, WA*

**What you plant matters less
than how you cultivate it.**

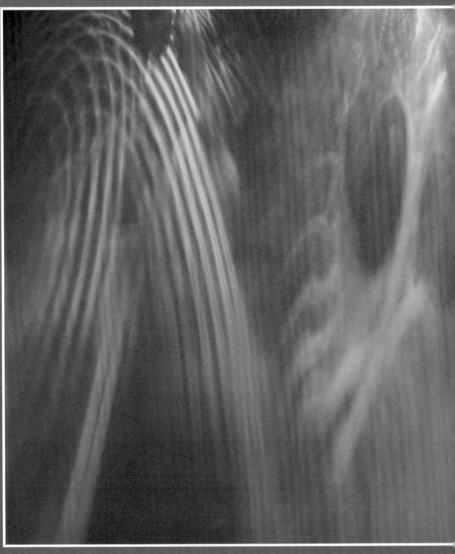

Seattle, WA

You are more powerful than you think.
How will you use that energy today?

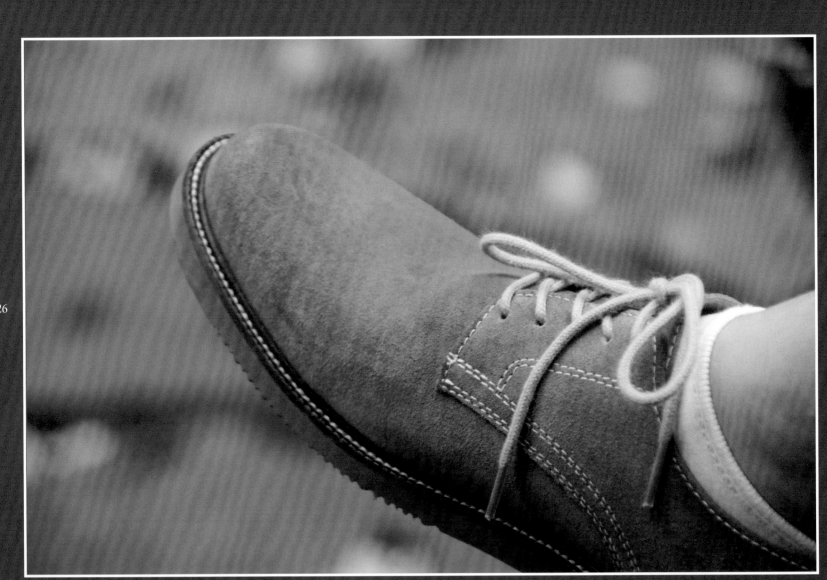

26

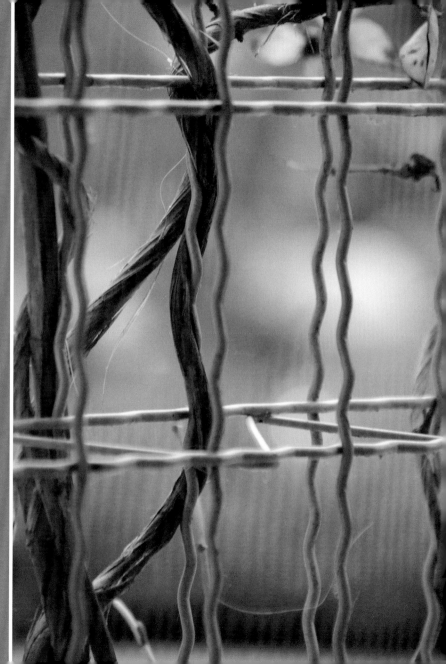

Clinging to old wrongs makes you an accomplice, not a victim. Make peace with your past, and go serve the world.

28

**Having your head in the clouds isn't necessarily a bad thing.**

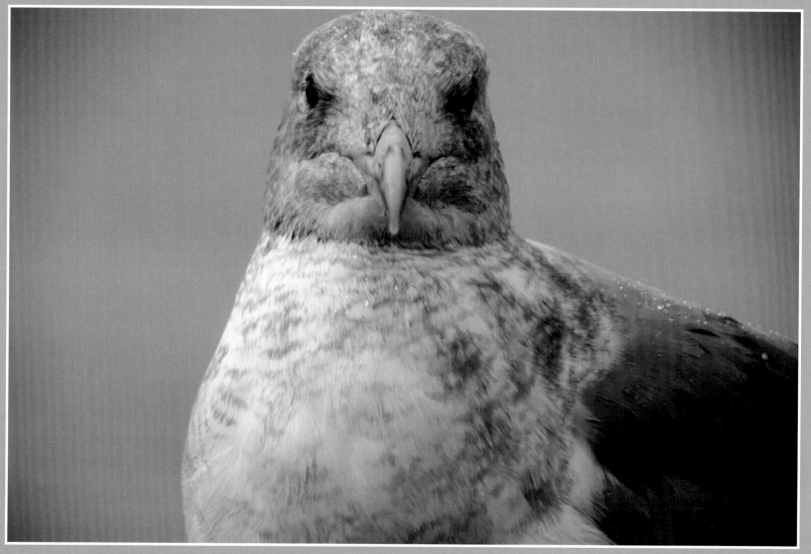

29

*Kingston, WA*

# When you make room for simple, you make room for the divine.

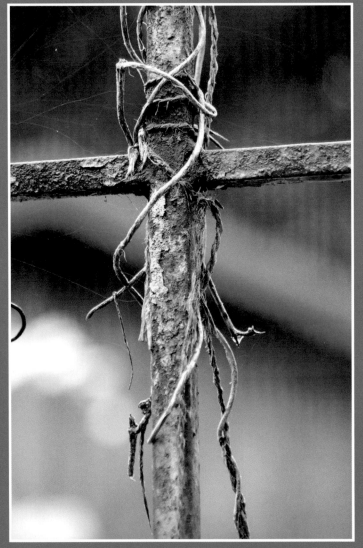

32

Kingston, WA

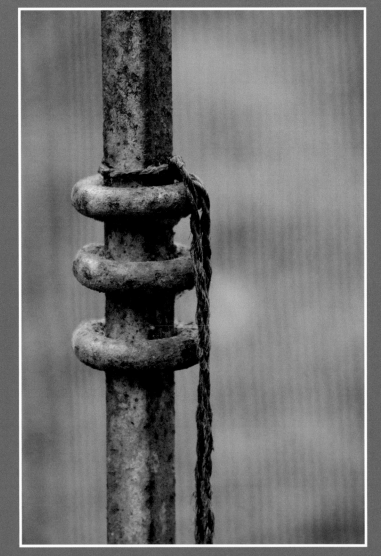

Kingston, WA

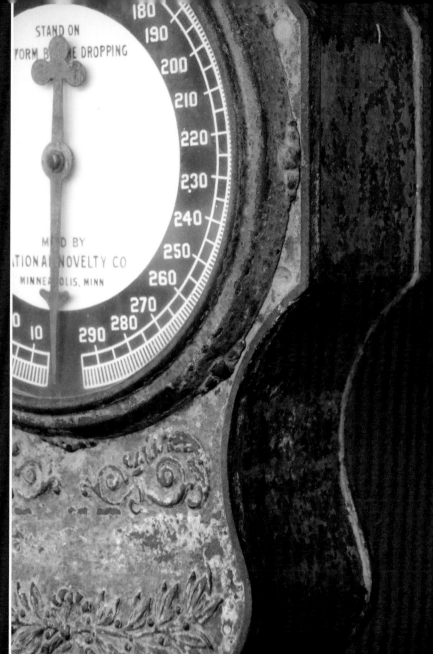

Give patience, love, and tolerance
more weight in your life.

*Kingston, WA*

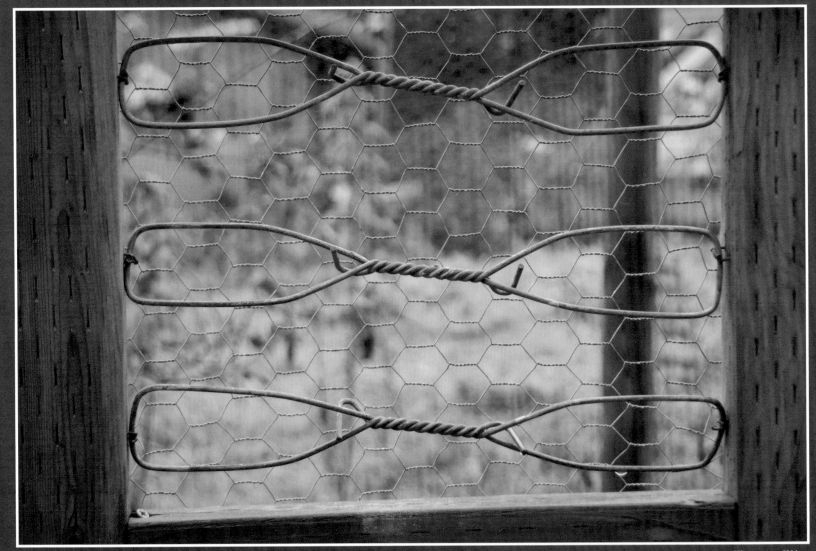

34

*Kingston, WA*

**Sometimes, when you least expect it, all the pieces come together.**

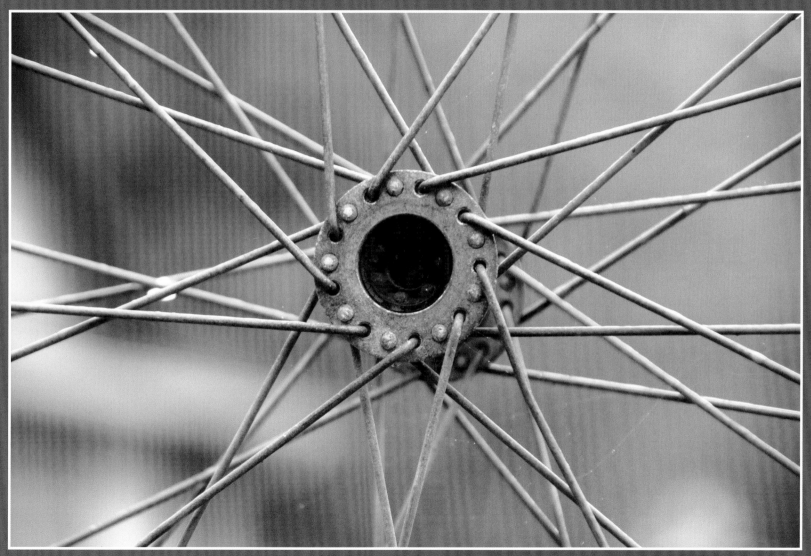

35

*Kingston, WA*

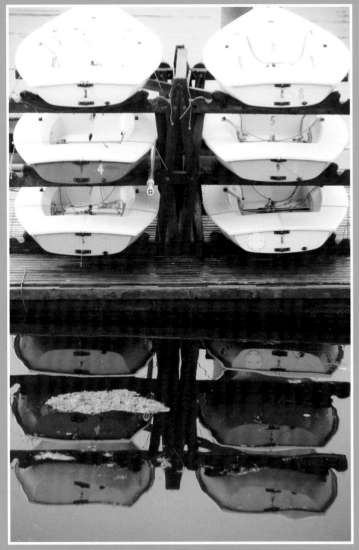

*Kingston, WA*

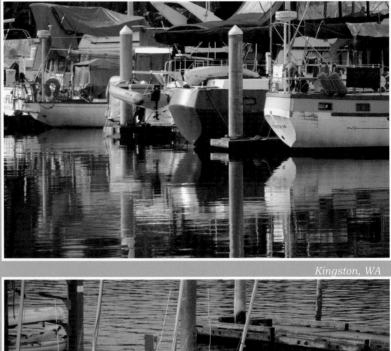

*Kingston, WA*

*Kingston, WA*

*Kingston, WA*

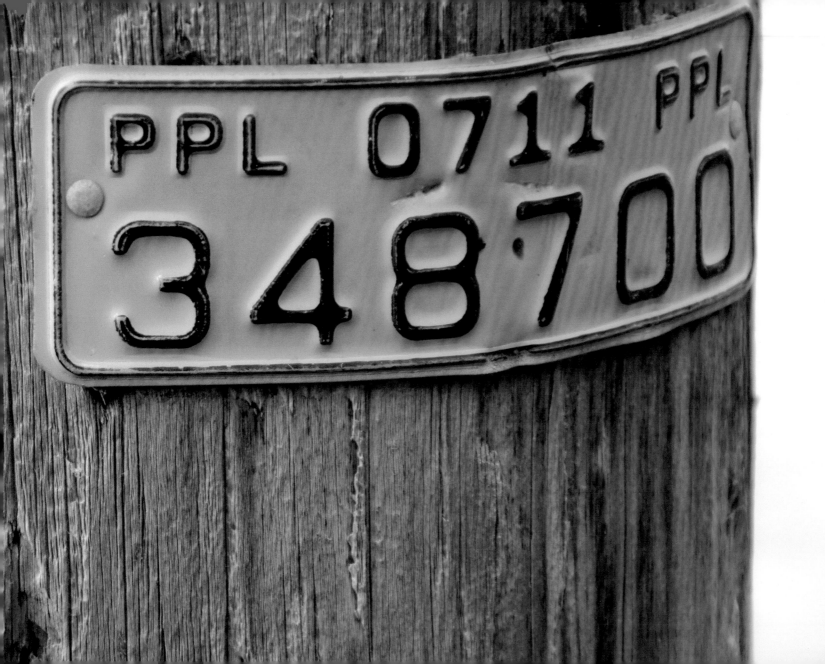

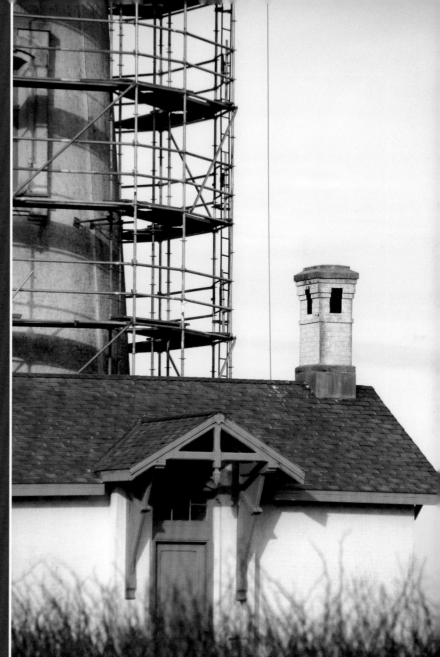

We are all works in progress.

Depoe Bay, OR
(opposite)

Depoe Bay, OR

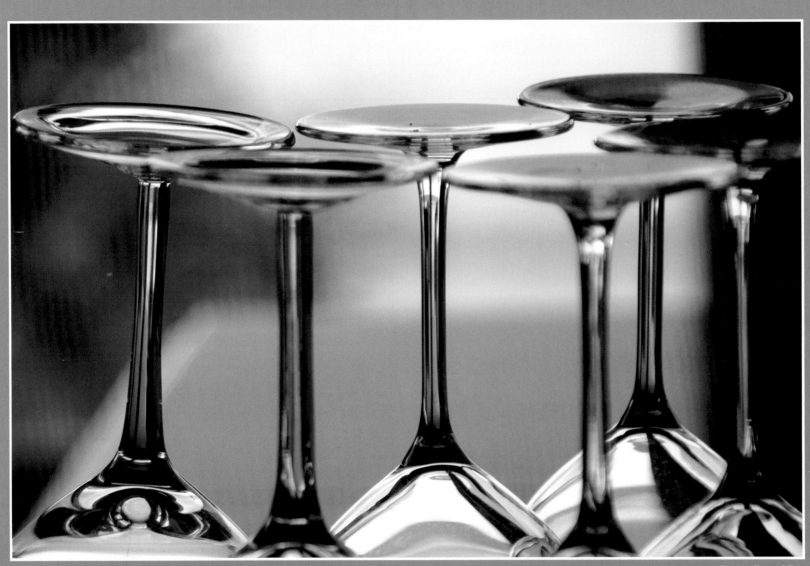

40

Depoe Bay, OR

**Freedom. It's an inside job.**

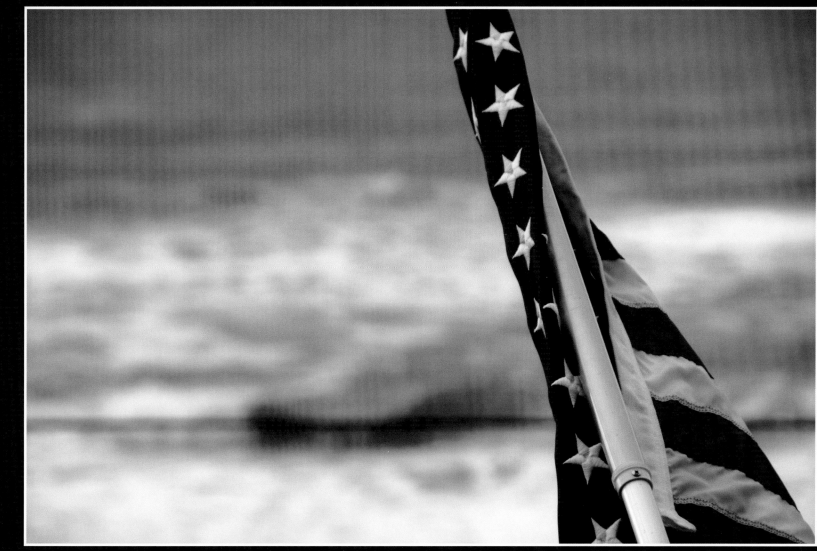

*Depoe Bay, OR*

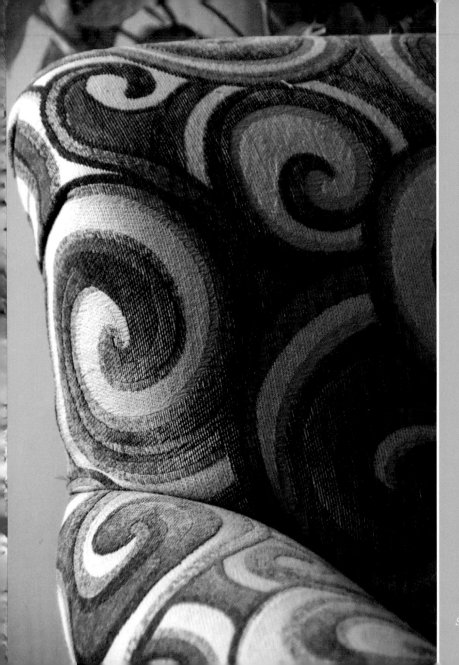

Pause.

*Santa Rosa, CA*

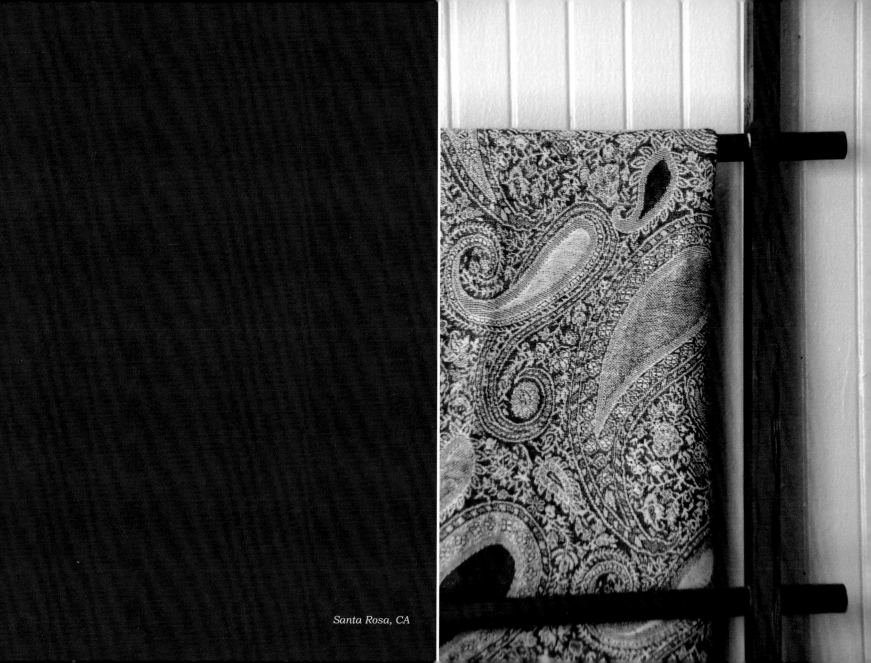

*Santa Rosa, CA*

# Learn to examine the common, and uncommon worlds will emerge.

46

*Bakersfield, CA*

Let there be no fences between friends.

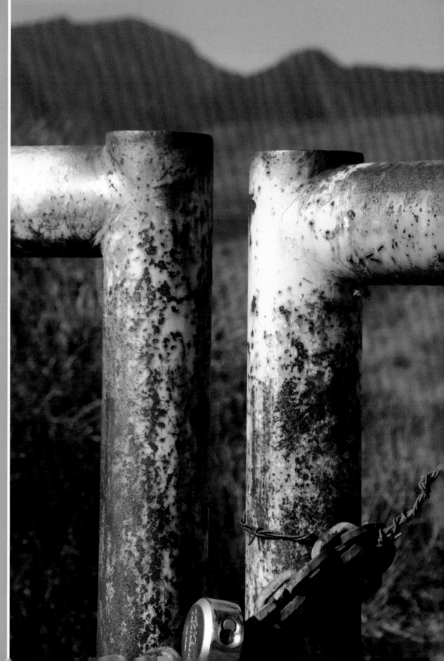

*Bakersfield, CA*

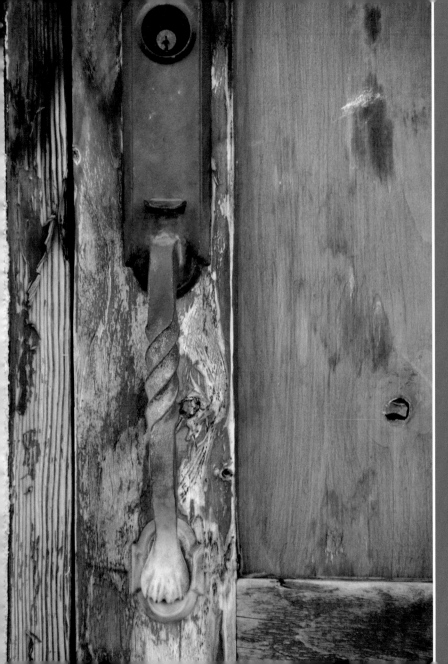

**Doors open and they close.
Trust the process.**

*Bakersfield, CA*

**Lonely is an illusion. You are never alone. You are always loved.**

*Bakersfield, CA*

**Lean toward the light.**

*San Diego, CA*

**Pour your love into the world, and watch it flow back to you in unexpected ways.**

*San Diego, CA*

**Make sure your own laundry is clean before you protest mine.**

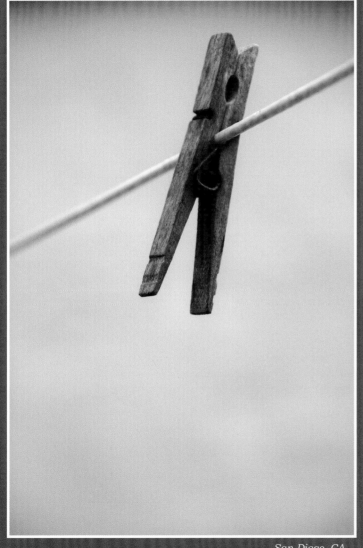

*San Diego, CA*

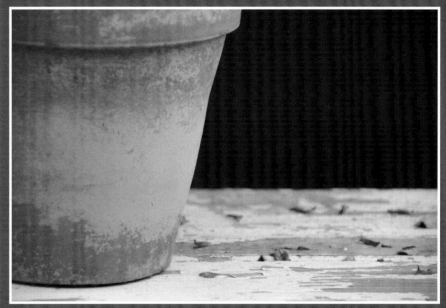

51

*San Diego, CA*

**Don't be afraid to outgrow your container.**

**Train your eyes to seek the ordinary, and you will always find the magic.**

*San Diego, CA*

53

54

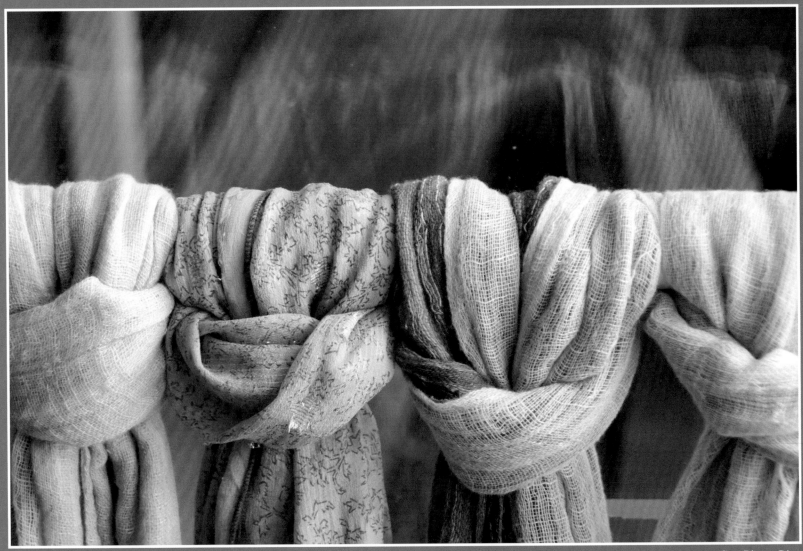

*San Diego, CA*

**If you focus on the flaw, you will miss the overall beauty.**

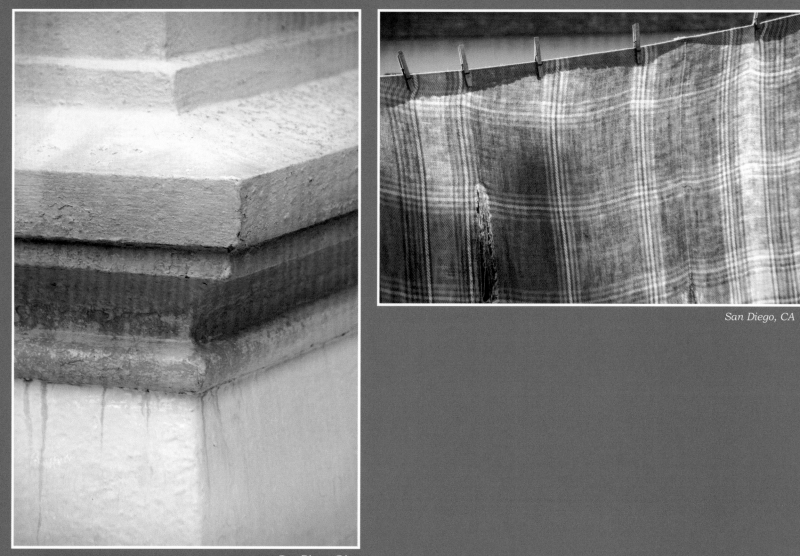

55

*San Diego, CA*

*San Diego, CA*

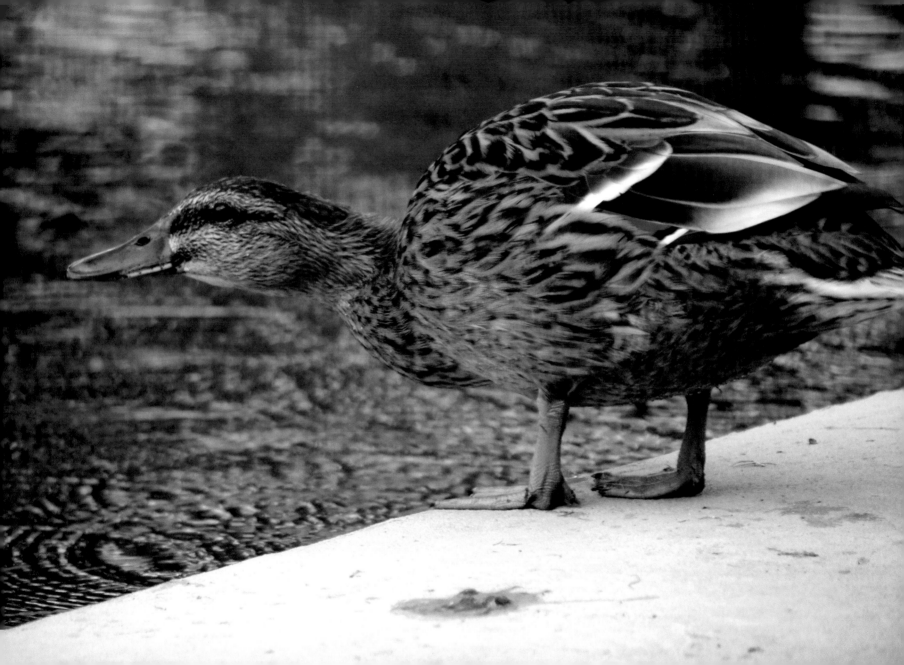

**Look beyond to truly see.**

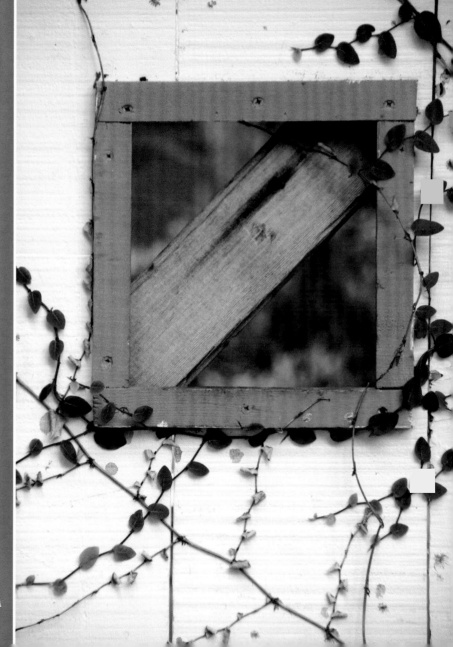

San Diego, CA
(opposite)

San Diego, CA

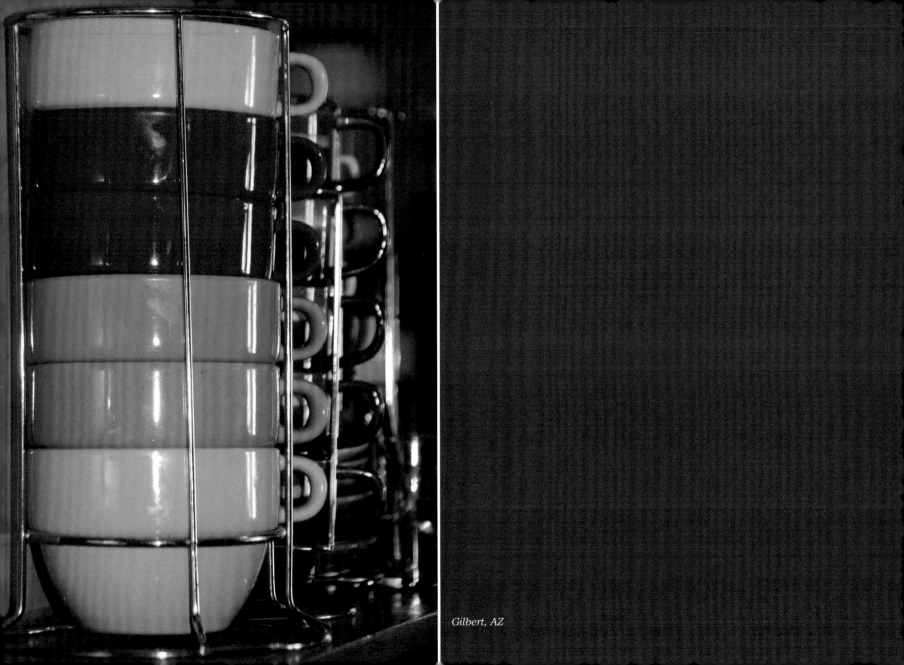

*Gilbert, AZ*

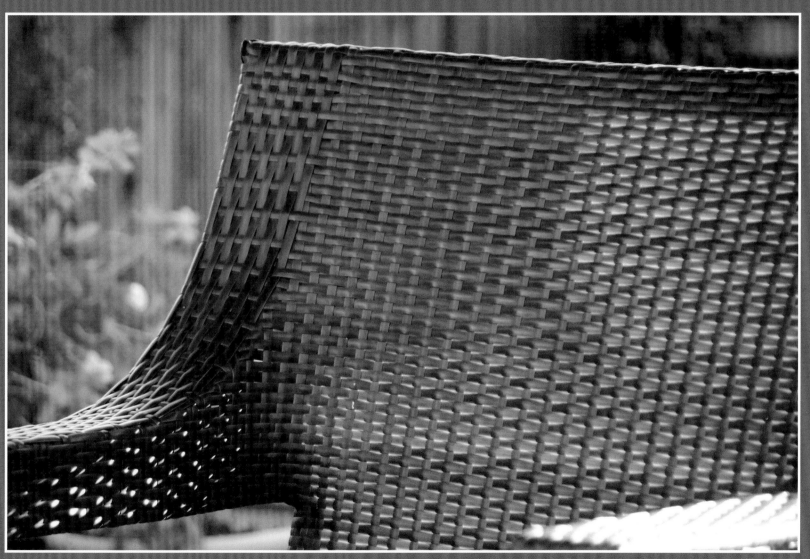

*Gilbert, AZ*

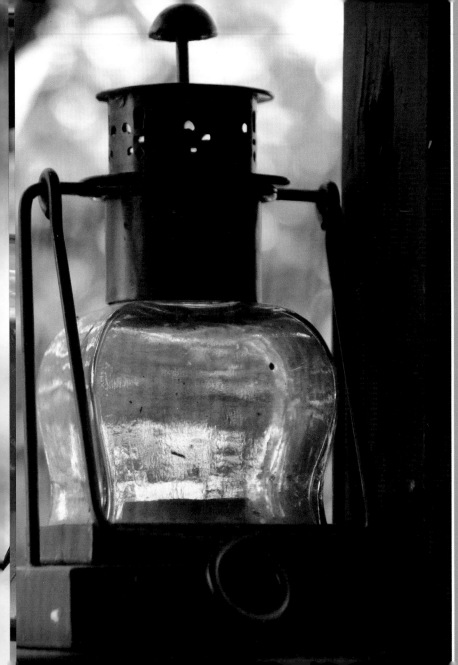

Greenwood, AR

**Hitch your wagon to your own star.**

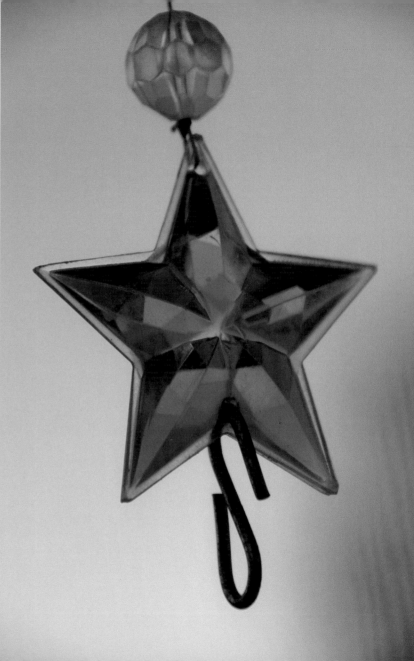

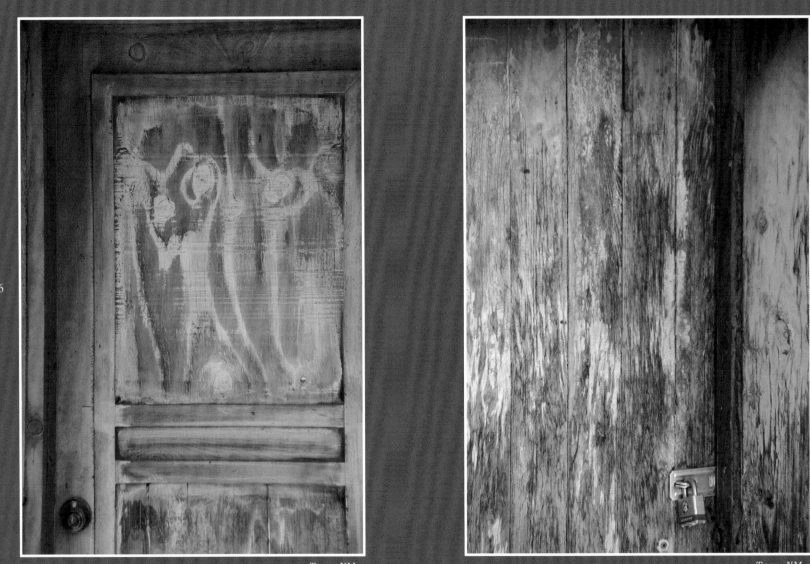

66

*Taos, NM*

*Taos, NM*

**If you're too quick to judge the outside,
you may miss some fine details.**

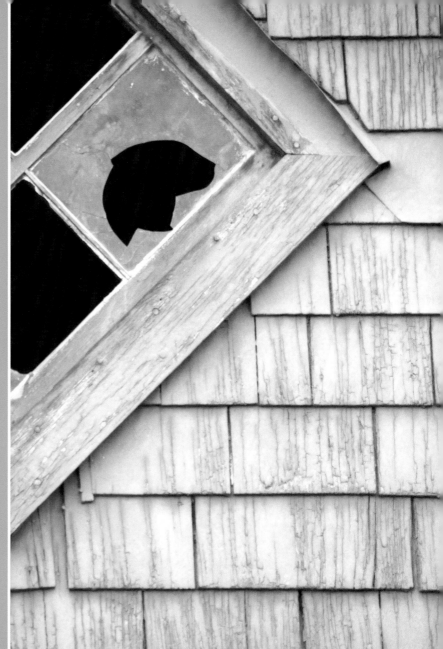

*Taos, NM*

**Pull up a seat.**

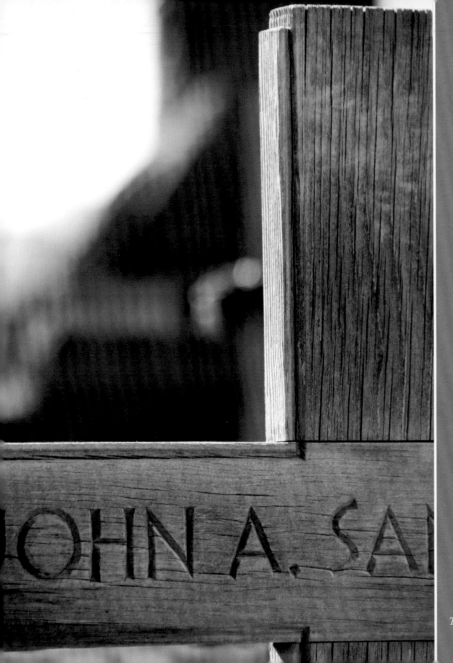

**Hold nothing back. Live with enthusiasm.**

*Taos, NM*

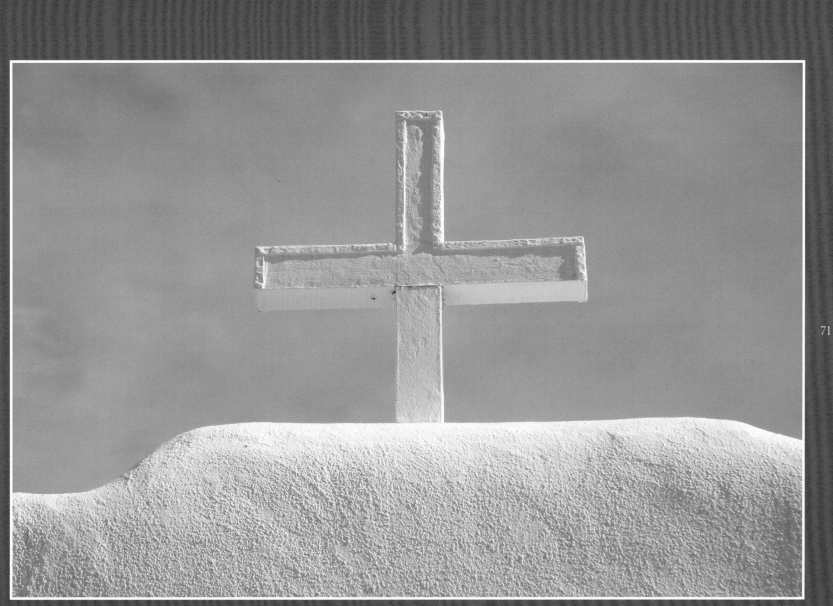

71

*Taos, NM*

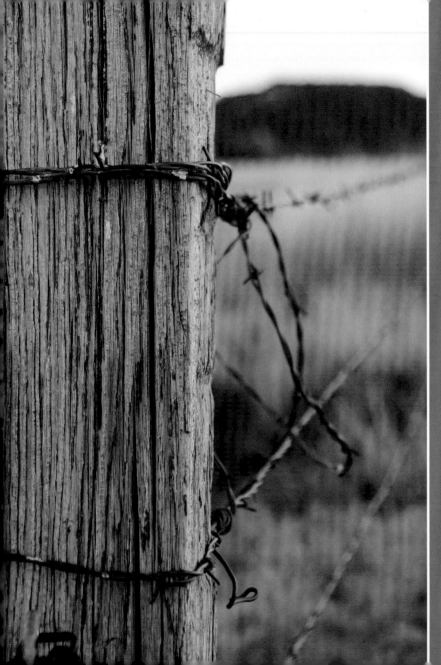

You are the only thing in the way.

*Tucumcari, NM*

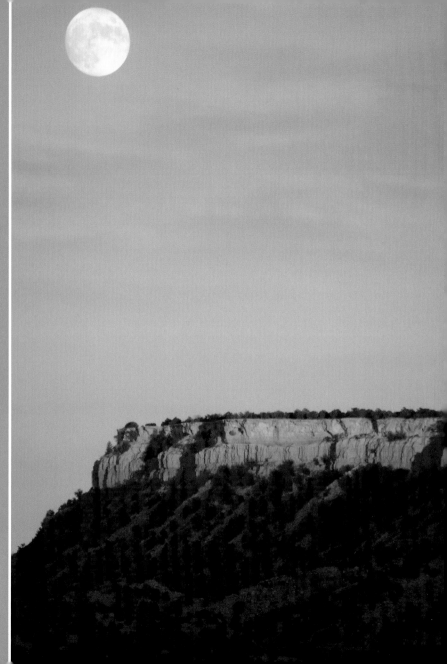

You have the power to amend a broken world.

*Tucumcari, NM*

The world needs your light. Burn bright.

The world needs your light. Burn bright.

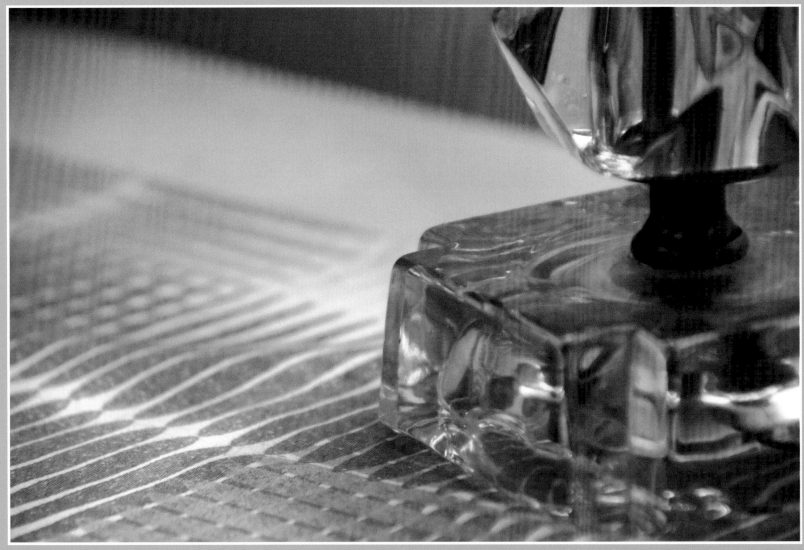

*Memphis, TN*

**Soften your gaze, and your heart will see more beauty.**

81

*Memphis, TN*

**Homes come in all shapes and sizes. Bring your heart.**

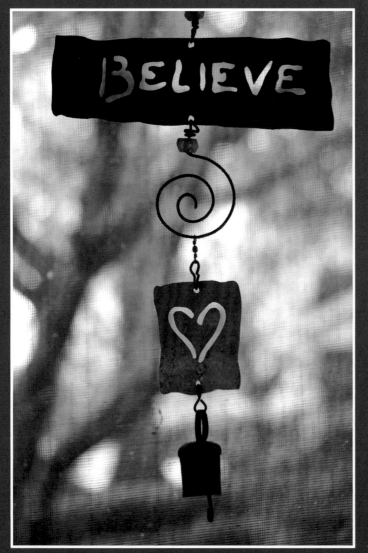

*Memphis, TN*

*Memphis, TN*

**Learn the facts, instead of assuming. Understand why, instead of judging.**

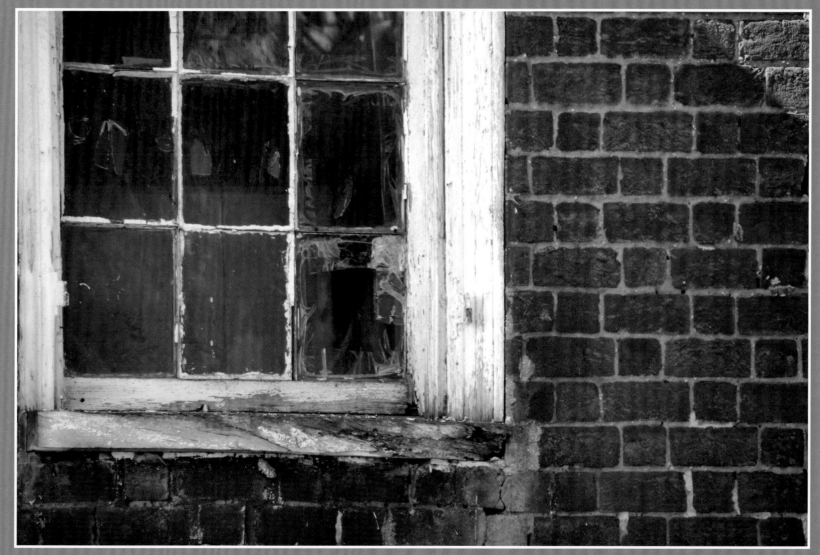

*Chuckey, TN*

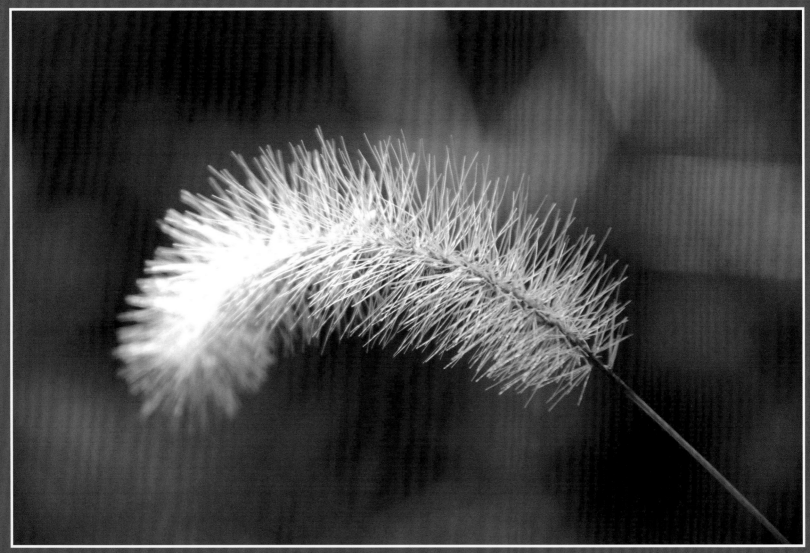

*Chuckey, TN*

**Fall in love with every detail of your life.**

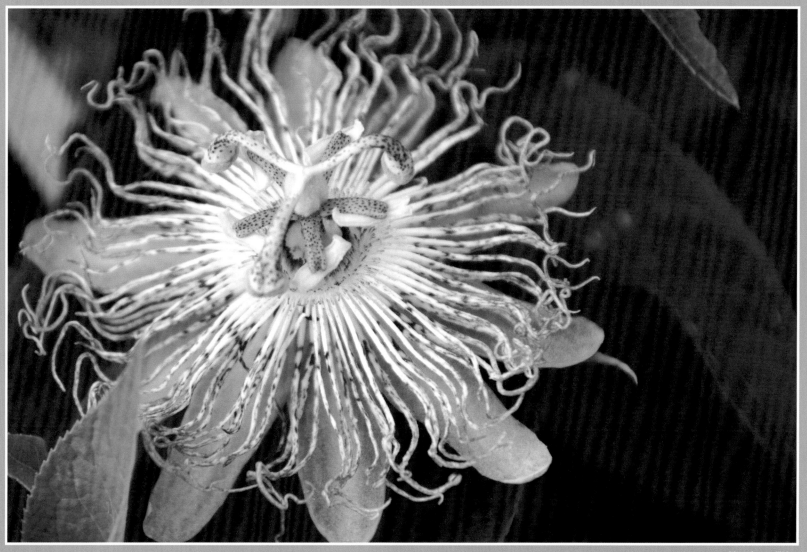

*Chuckey, TN*

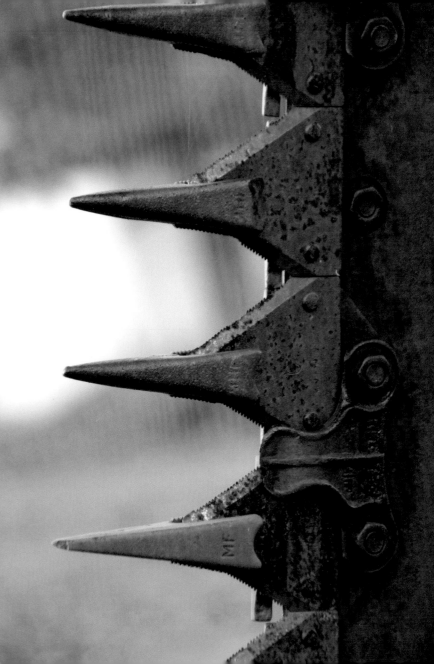

**Investigate the unseen
wonders of all things.**

*Greenville, VA*

*Greenville, VA*

The seeker in me honors the seeker in you.

*Allentown, PA*

95

*Allentown, PA*

*Allentown, PA*

**Bring the best version
of yourself to the table.**

**All roads lead home.**

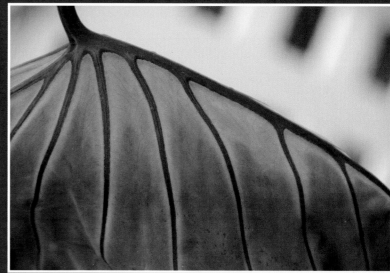

*Allentown, PA*

**It's your life. Stop waiting for someone else to show up with the key.**

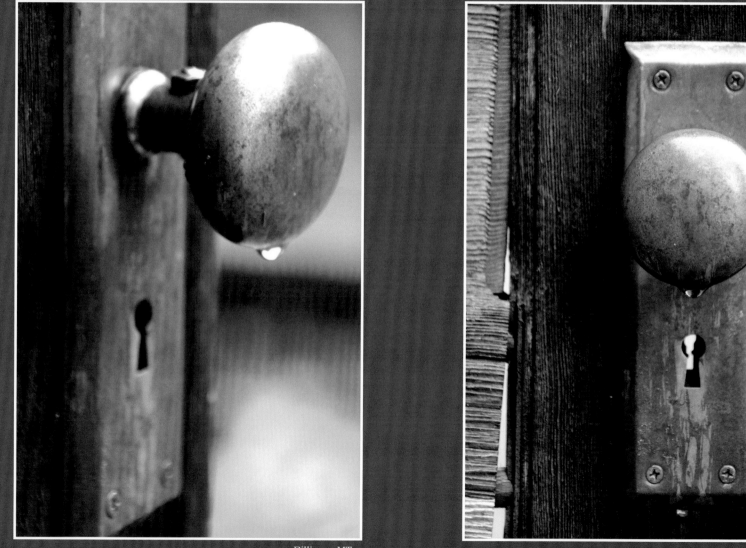

*Billings, MT*

*Billings, MT*

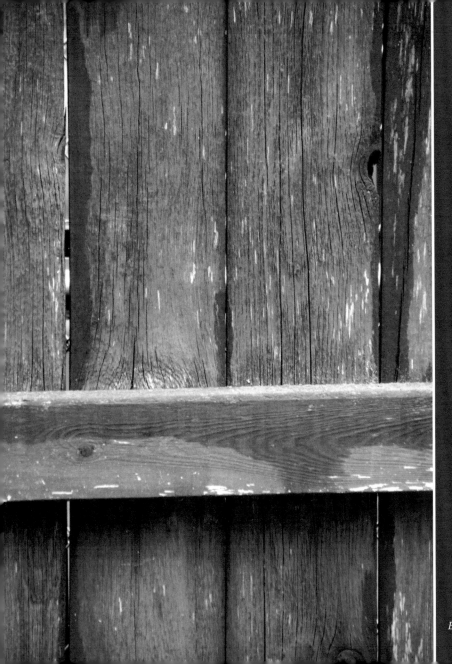

Let your true colors improve with time.

*Billings, MT*

**You can focus on the differences
or appreciate the strength of the collective effort.**

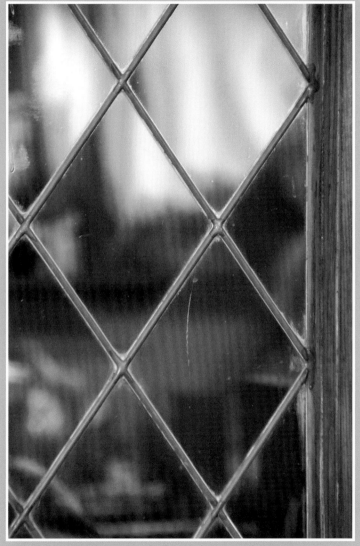

*Detroit, MI*

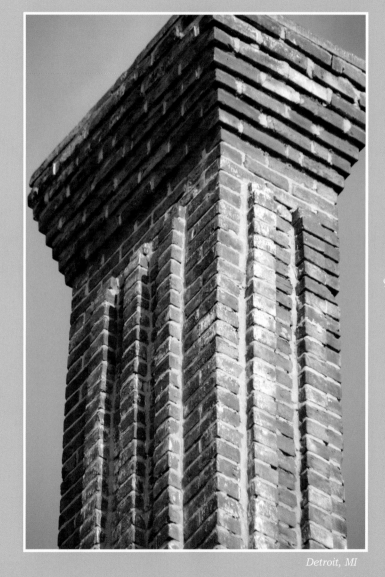

99

*Detroit, MI*

*Detroit, MI*

**If your own life is interesting and productive,
you will have no impulse or desire to criticize others.**

*Savannah, GA*

## Make love your currency.

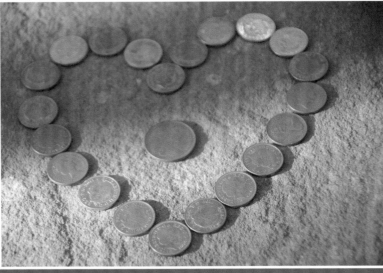

*Rhinebeck, NY*

102

## Follow your curiosity.

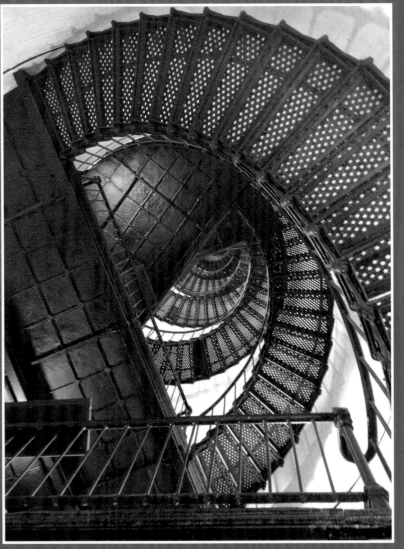

*Hunting Island, SC*

**All life springs from the sacred.**

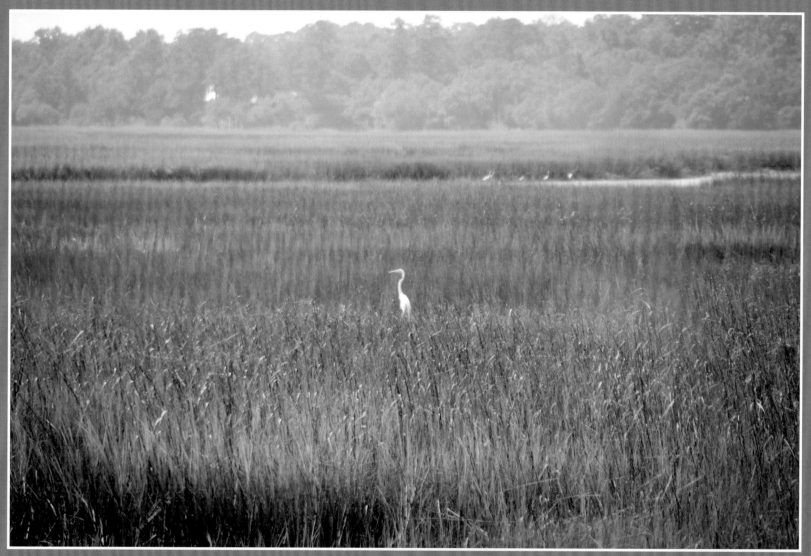

*Hunting Island, SC*

**Doors open when you pursue your passion, purpose, and bliss.**

**Not all artwork is in museums.**

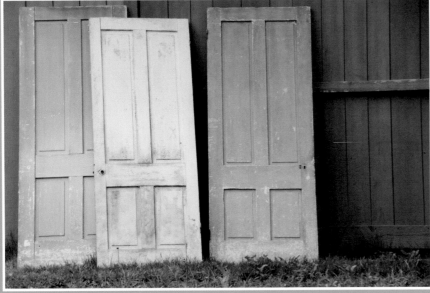

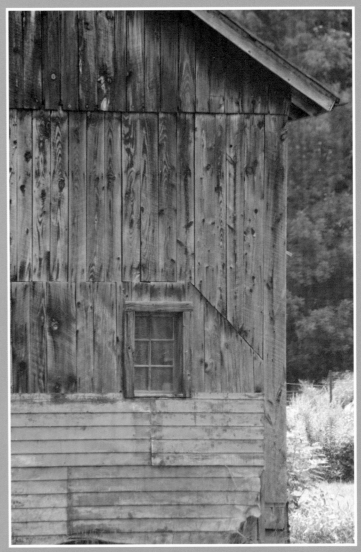

104

*Jamaica, VT*

*Jamaica, VT*

Use that fence you've built around your heart to climb out of the prison.

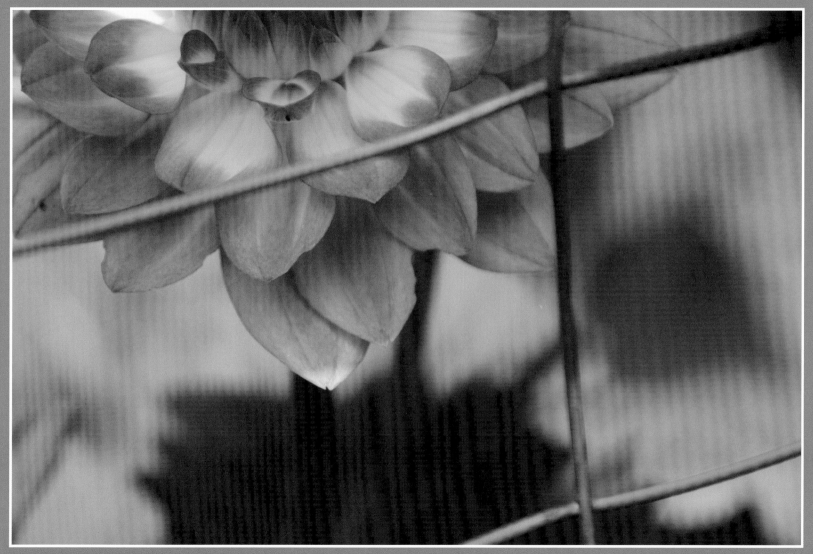

*Jamaica, VT*

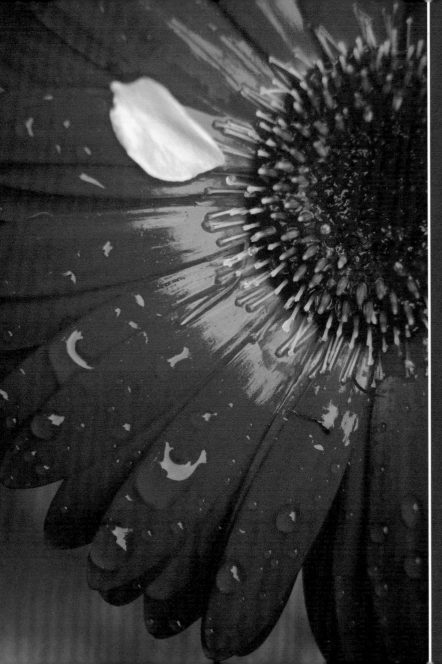

Growth requires equal parts
sun and rain. Welcome both.

*East Greenwich, RI*

Take comfort in the memories
and strength from the knowledge
that all love given returns.

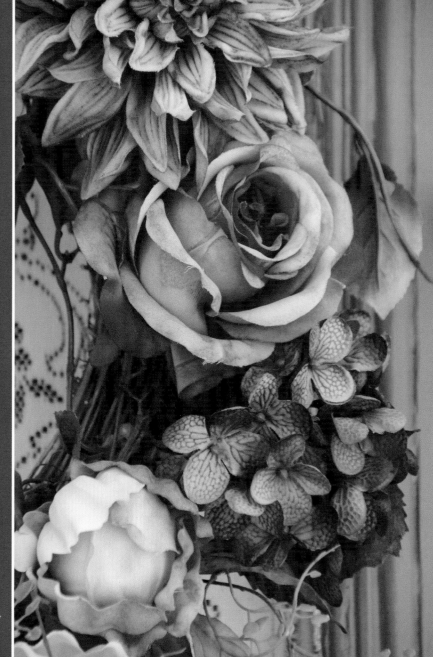

*East Greenwich, RI*

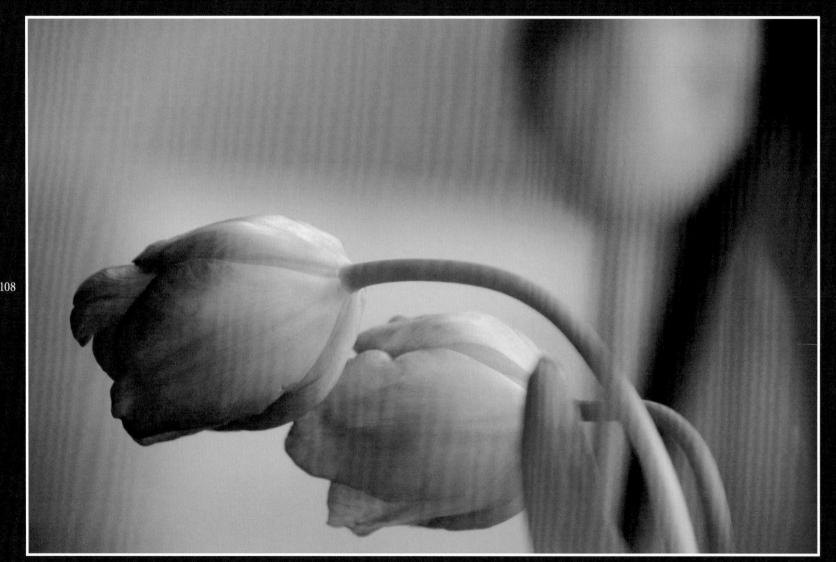

108

*East Greenwich, RI*

**See to it that your own house is in order.**

**Invest in faith. Devalue fear.**

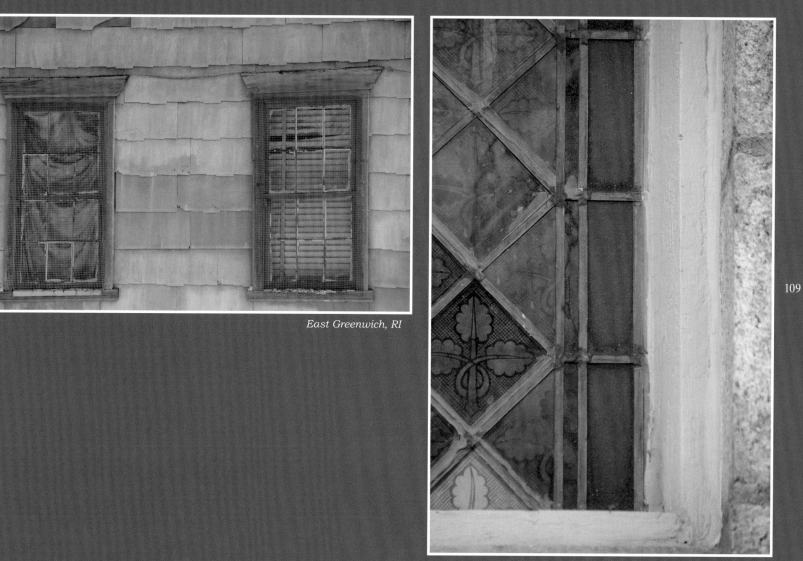

*East Greenwich, RI*

109

*East Greenwich, RI*

*East Greenwich, RI*

**In the right light, even our rough edges can have beauty.**

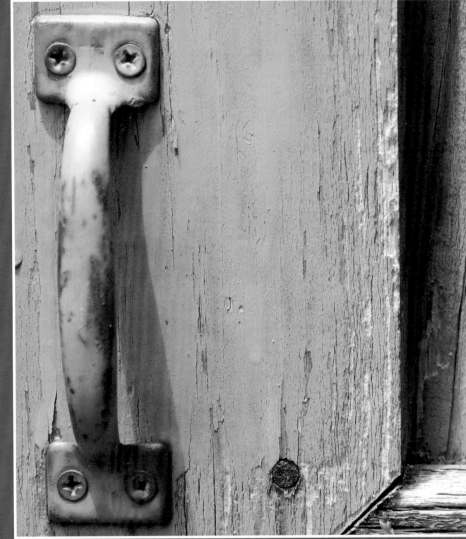

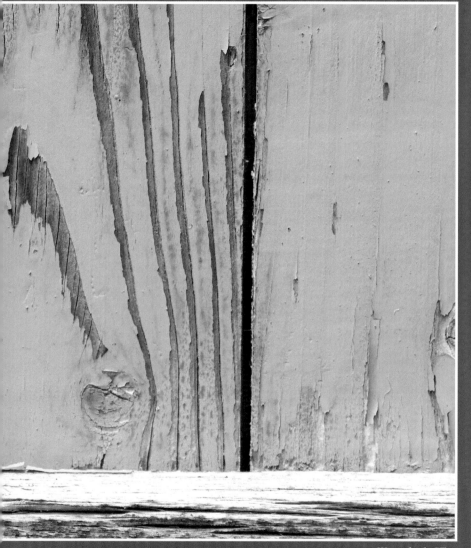

*Waterford, CT*

Sometimes, when you least expect it, happiness enters through a crack in the door.

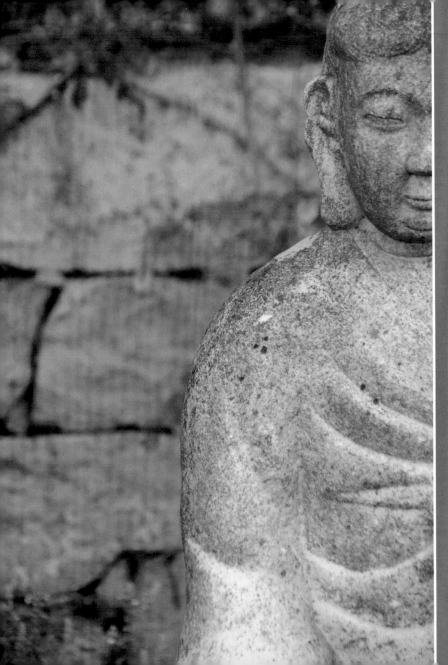

**Come as you are.**

*Waterford, CT*

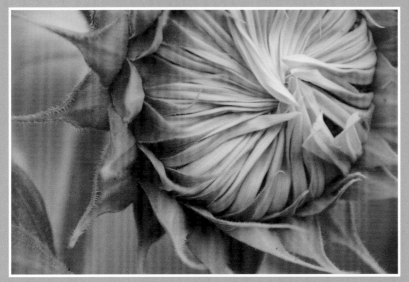

*Griswold, CT*

**Reveal the best version of yourself.**

**Dare to stand out in a crowd.**

*Griswold, CT*

**Honor your inner circle.**

**The Universe will reward
you for saying, "Yes!"**

*West Greenwich, RI*

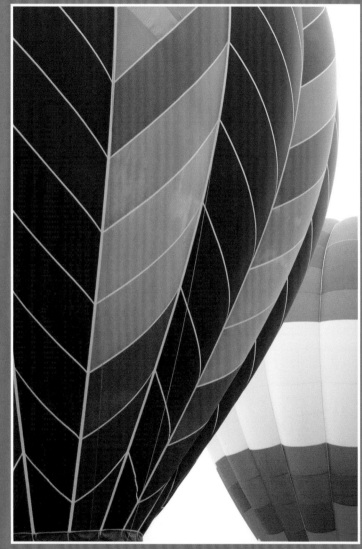

*Kingston, RI*

**Gently remove those layers
that no longer serve you.**

**Maybe it's not your door.**

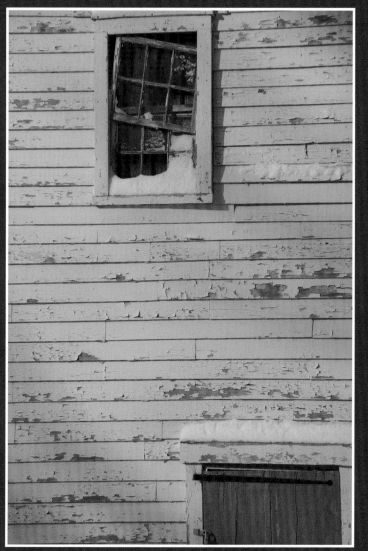

*Wickford, RI*

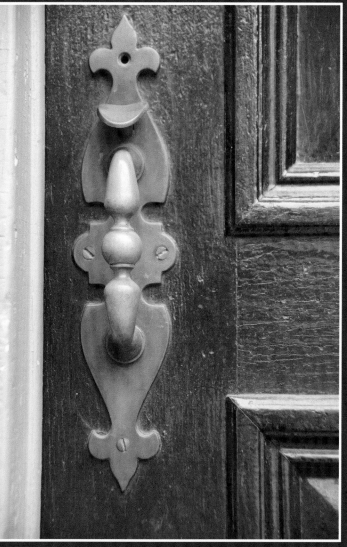

11

*Wickford, RI*

**A grateful heart is your reward
for a day well lived.**

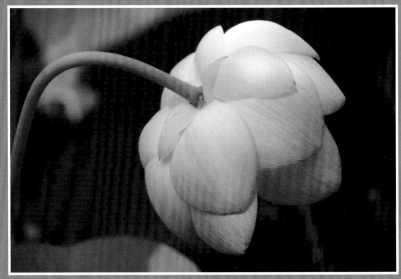

*Wickford, RI*

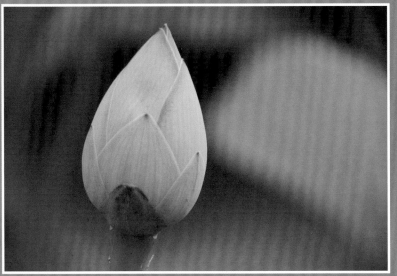

*Wickford, RI*

**Nature's timing is impeccable.**

Life is hard.
Then it isn't.

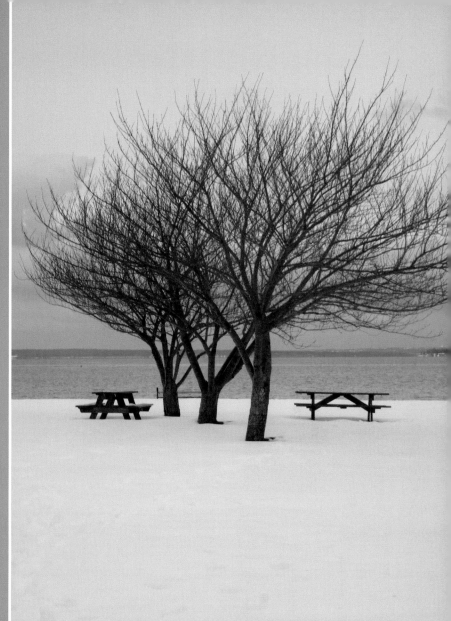

*Wickford, RI*

# Pause.

# Fear and love cannot occupy the same vessel.

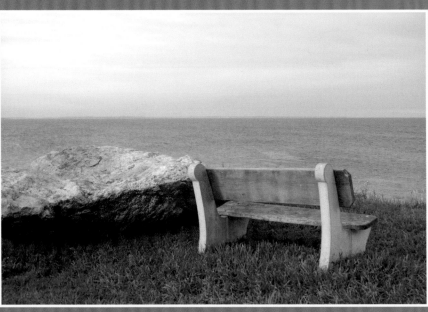

*Narragansett, RI*

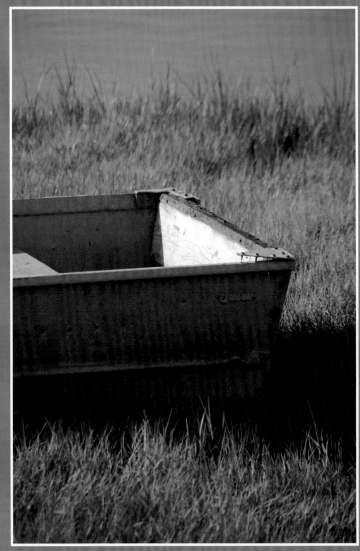

*Harwichport, MA*

# Let go of the shore.

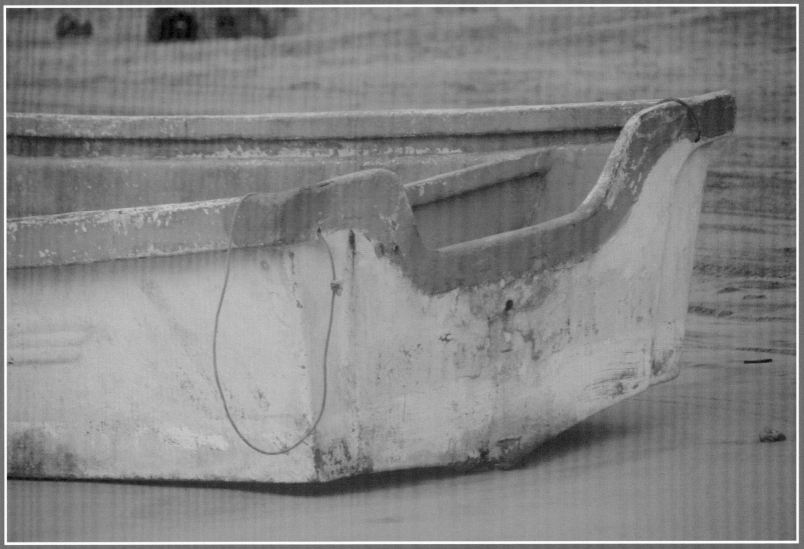

*Provincetown, MA*

## About the Author

Carol Mossa is a healer in private practice in East Greenwich, Rhode Island, and the founder and creator of Earth's School Of Love: Healing the Planet, One Thought at a Time, a community-based Facebook page with a global following. Carol's original photographs and inspirational verses can be found in bookstores, boutiques, and private collections throughout the United States. Greeting card sales help her travel around the country spreading messages of hope, love, and abundance. You are invited to connect with her at http://fb.com/EarthsSchoolOfLove, or through her website at http://www.EarthsSchoolOfLove.com.